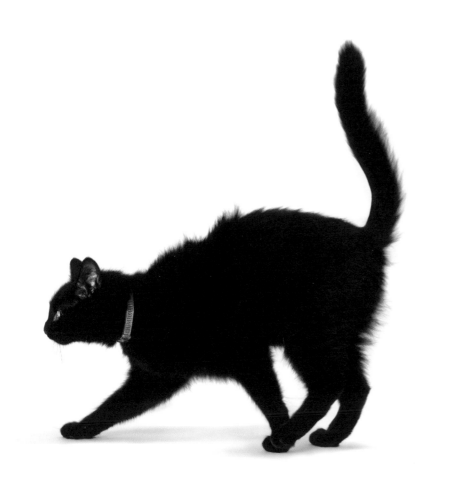

D1308842

Different Strokes

The Difference
Between Cats & Dogs

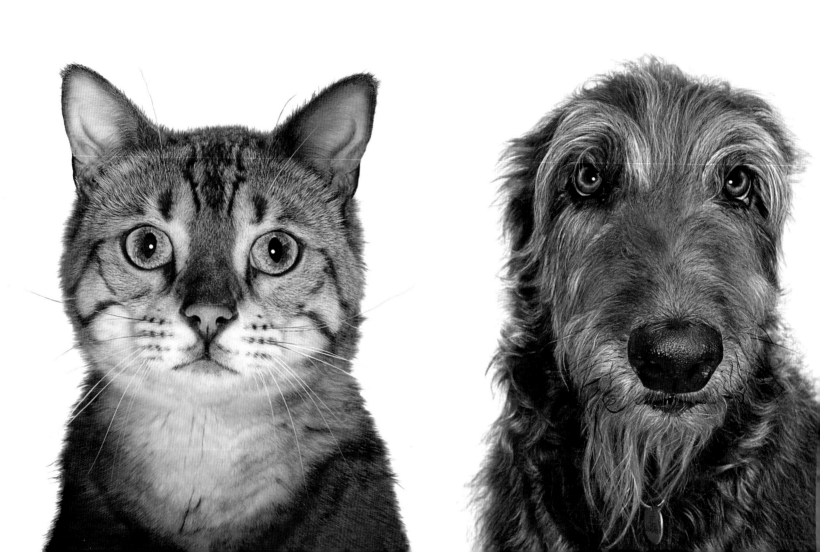

Different Strokes

The Difference Between Cats & Dogs

GANDEE VASAN

WORDS BY PATRICK REGAN

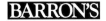

Yin.

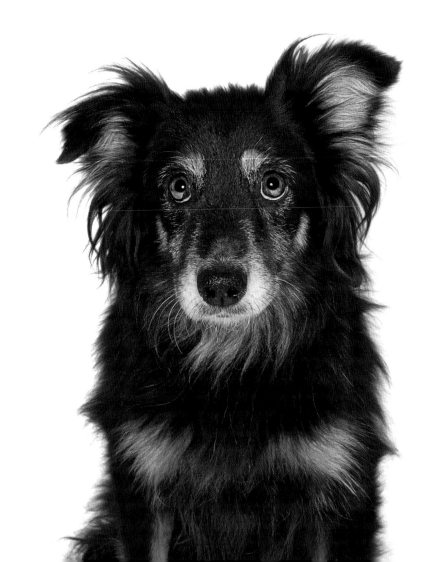

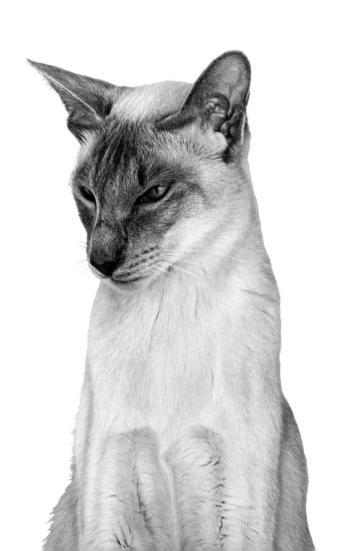

Yang.

True.

Blue.

Loyal and obedient.

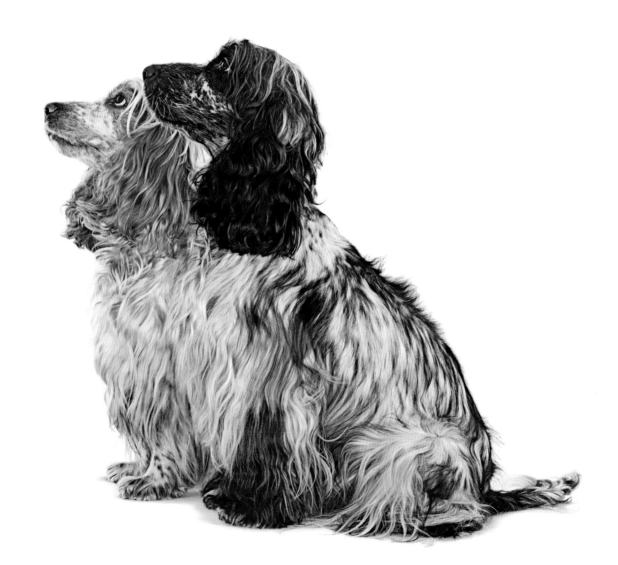

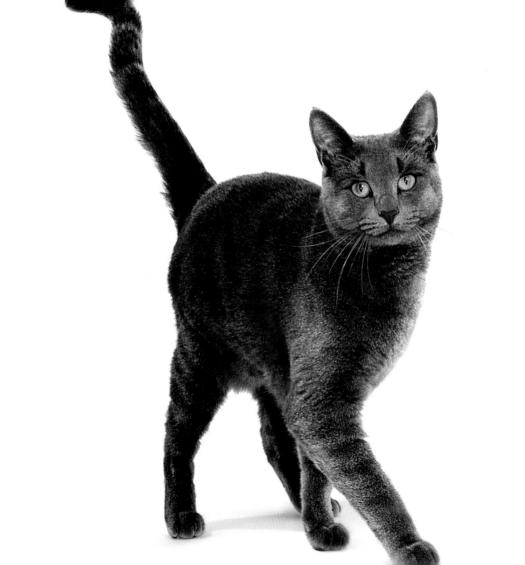

Elegant and mysterious.

The way we see ourselves?

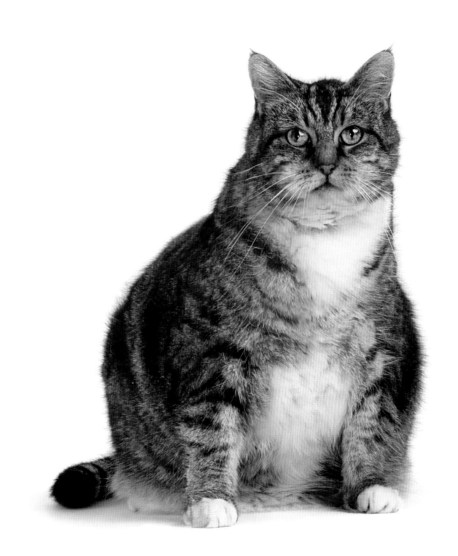

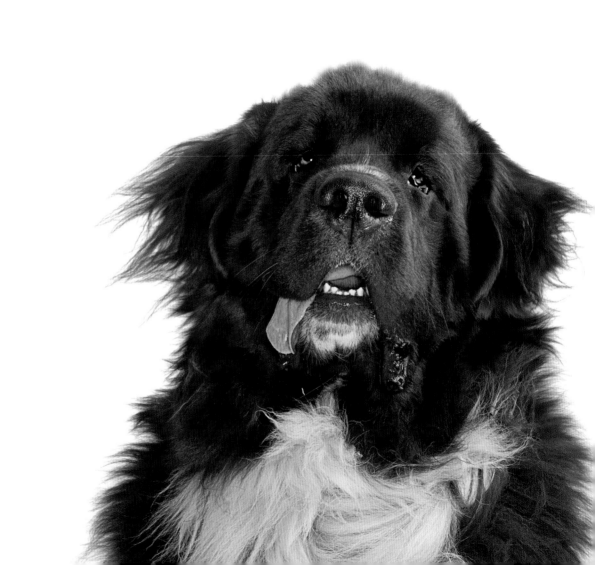

The way others see us?

Centuries pass.
And still the de

Millennia even.

bate rages on ...

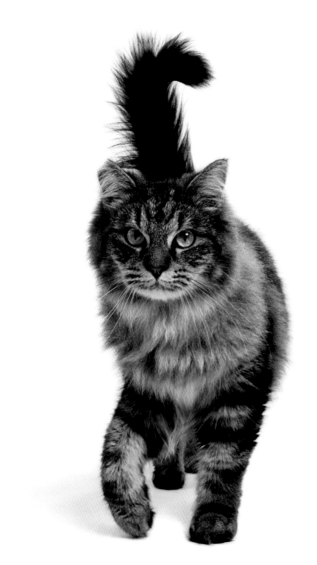

Cat person?

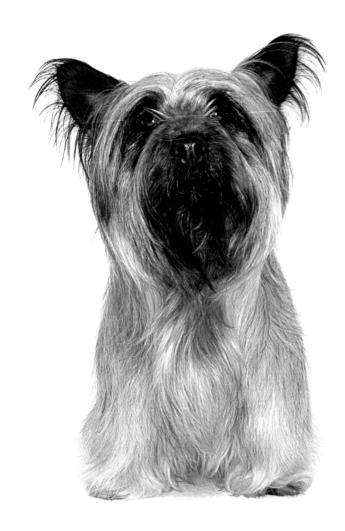

Dog person?

Though no one forces us

Cat person or

And what does it

to choose, many of us do.

dog person?

say about you?

Dogs are faithful, protective, and cheerful.

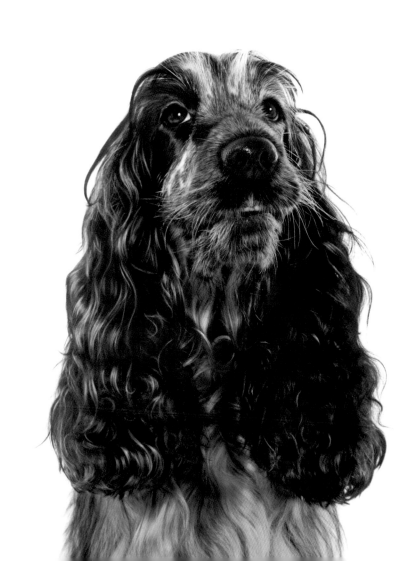

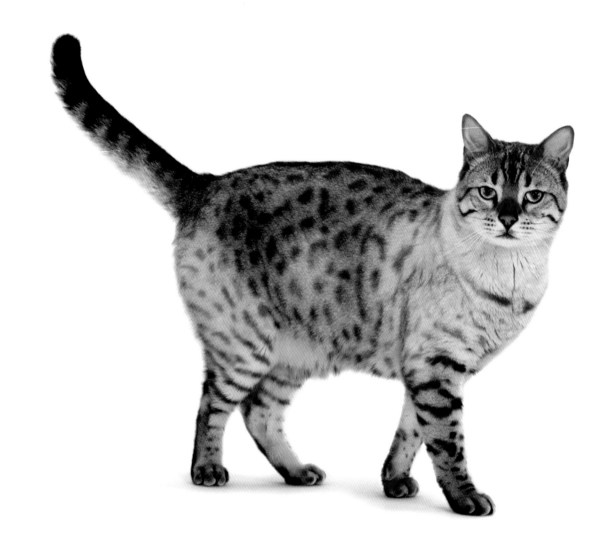

Cats counter with confidence,
grace, and aplomb.

Dogs, it has been observed, come when they're called.

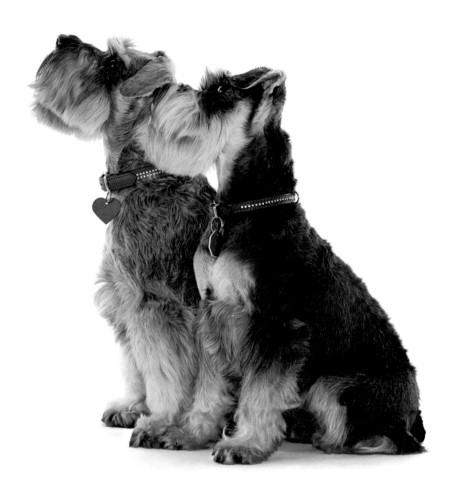

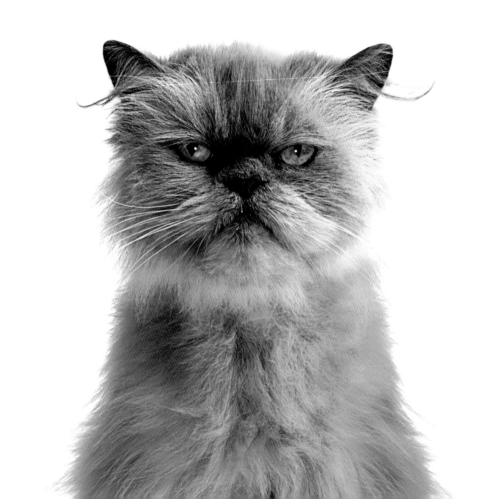

Cats take a message and get back to you.

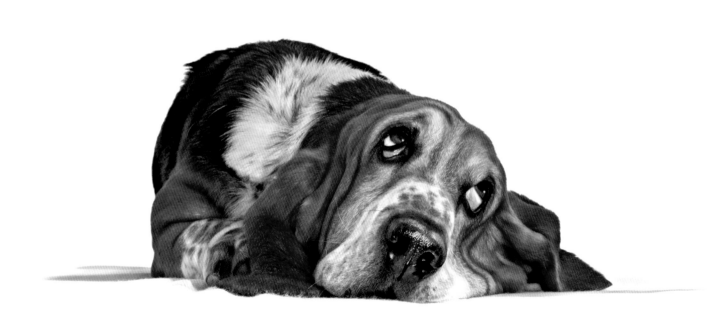

Dogs charm us.

Cats enchant us.

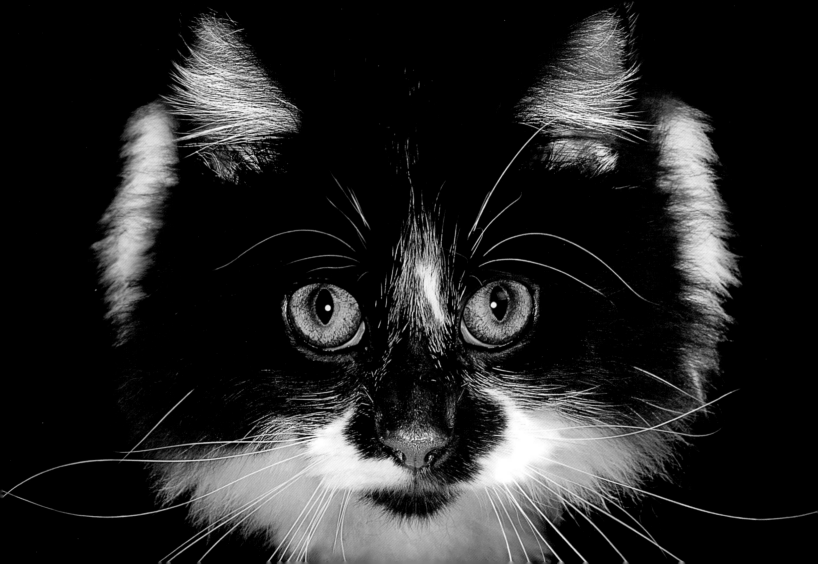

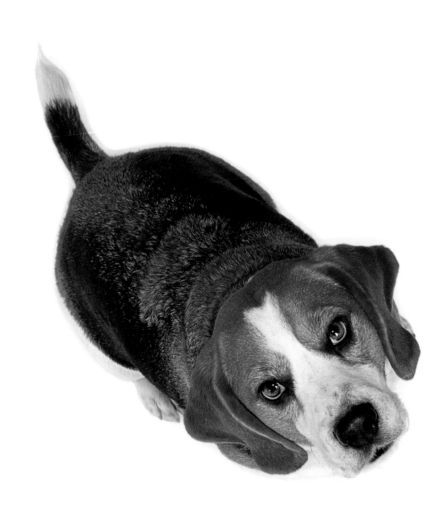

Dogs attentively
await our
command.

Cats are quietly
amused by
our requests.

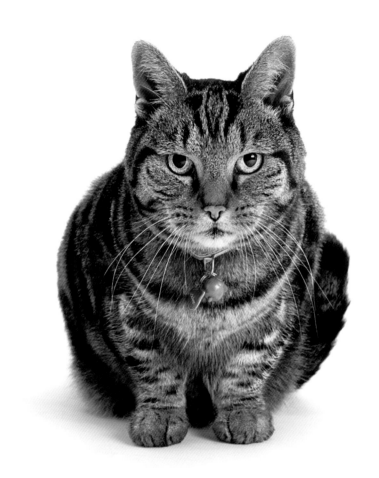

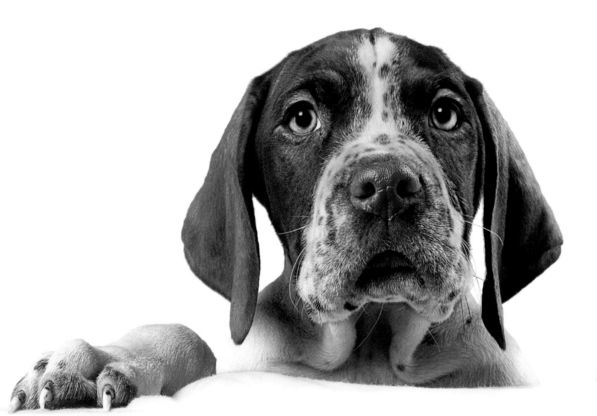

Dogs keep you company.

Cats keep you guessing.

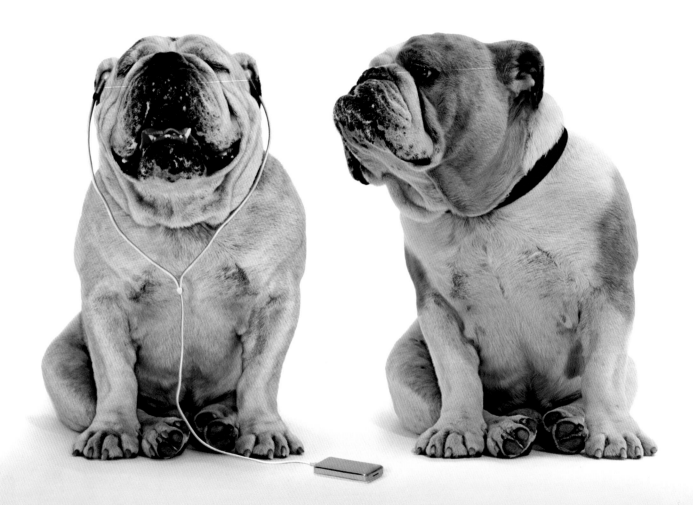

Dogs are the most
domesticated of animals.

Cats retain an
unknowable wildness.

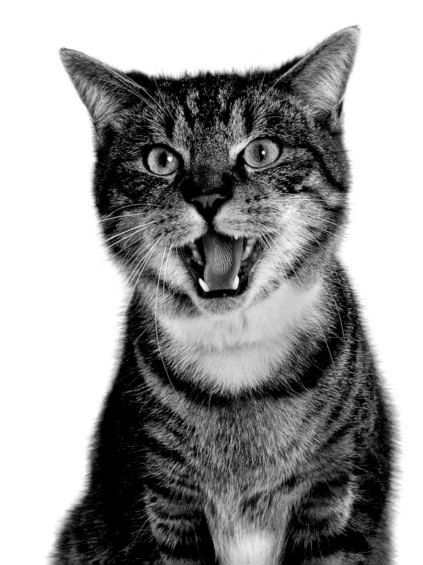

Dogs capture our hearts.

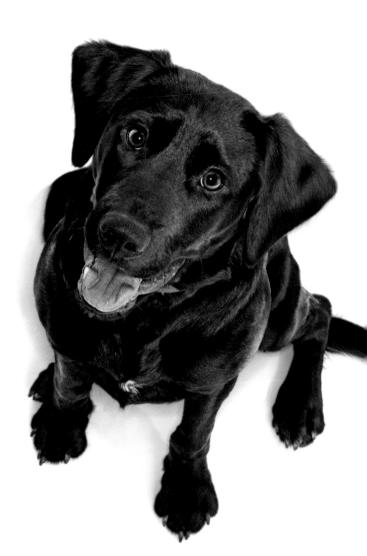

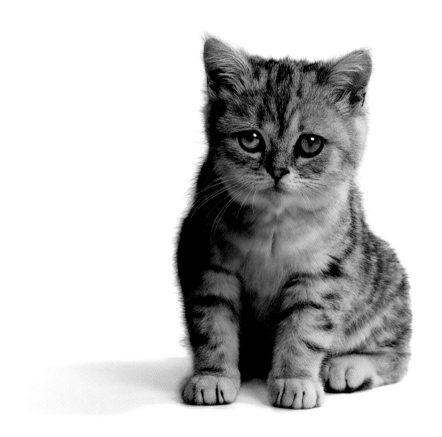

Cats captivate our souls.

Each species teaches us.
From cats we learn to be cool ...

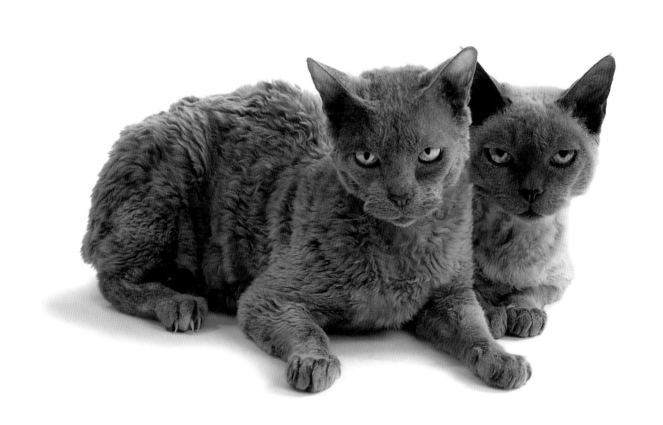

Curious …

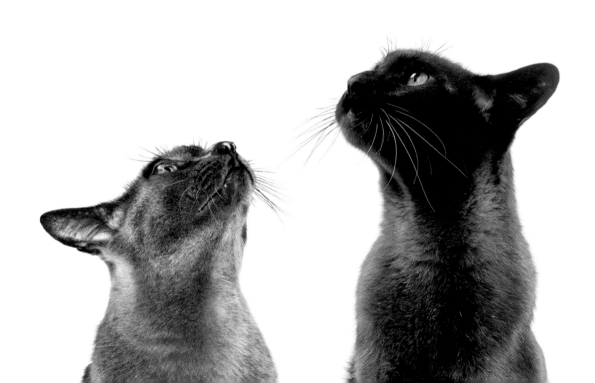

Frisky ...

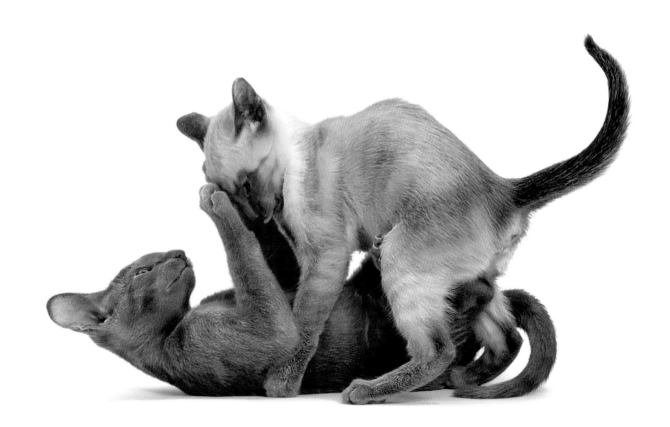

And always alert.

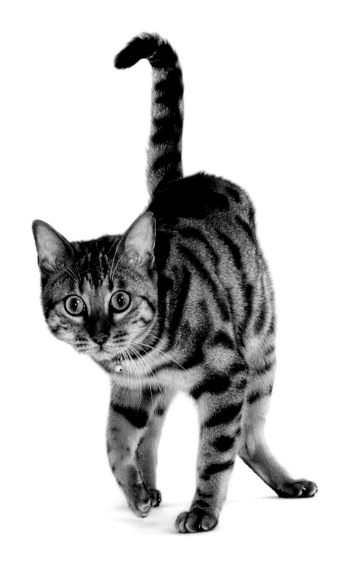

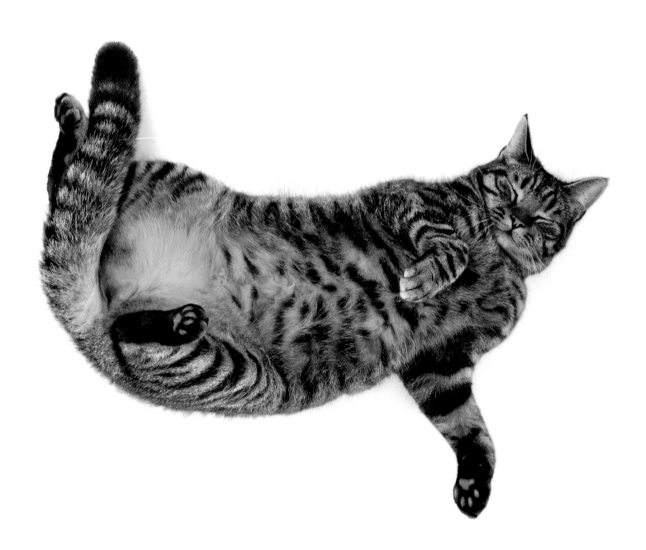

(... well, almost always).

From dogs we pick up pointers
(yes, pointers) on devotion ...

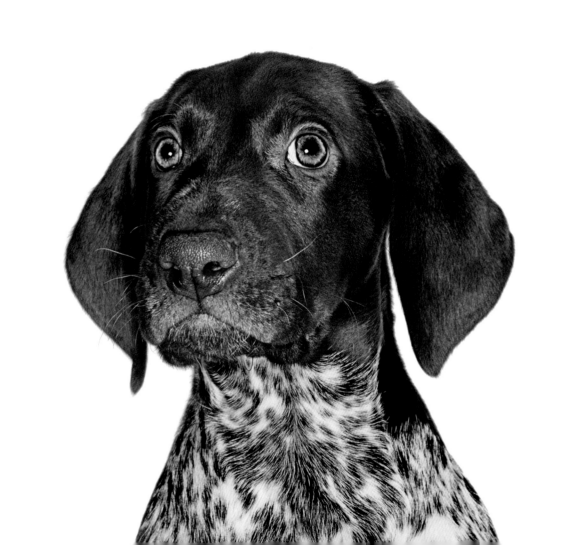

Duty ...

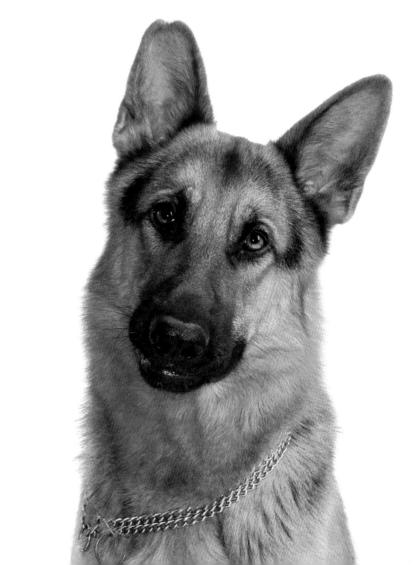

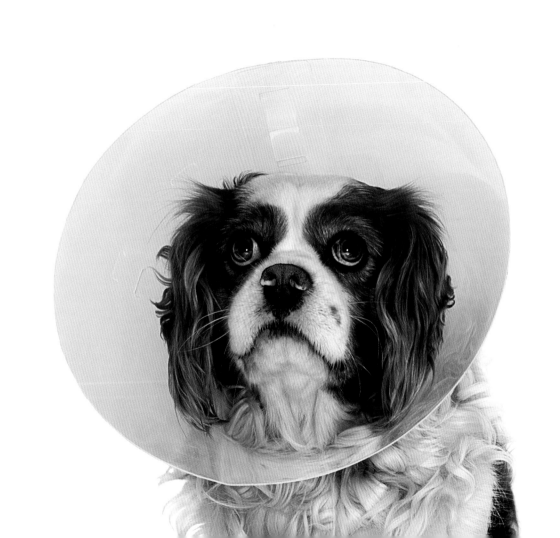

And dignity

(... even in undignified circumstances).

Dogs teach us how to get along
despite our differences ...

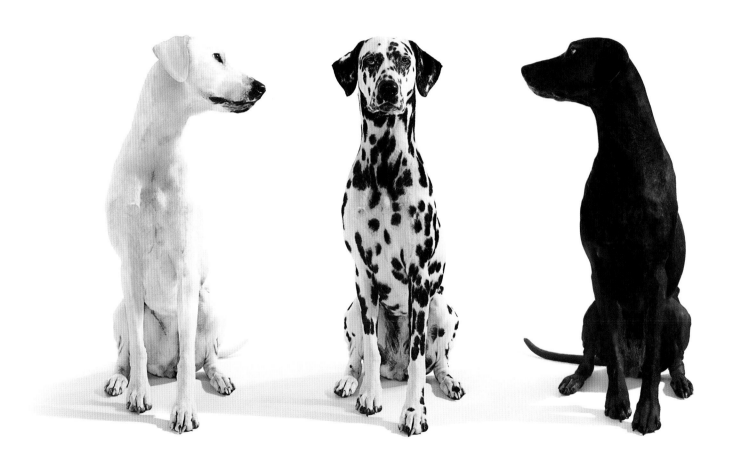

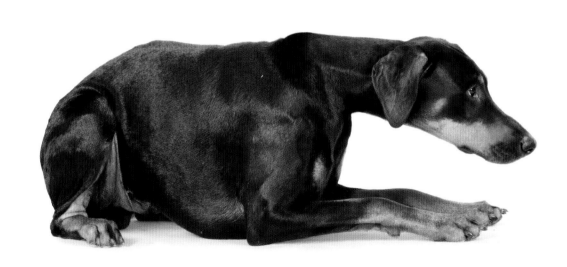

And to stand tall no matter
the size of the other guy.

And though—with the possible exception of poodles—dogs seem somehow less French than cats, it is the canine that most ardently embodies that ebullient French phrase *joie de vivre*—the joy of living.

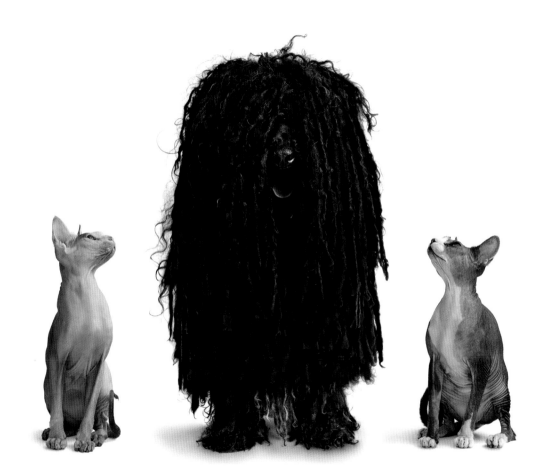

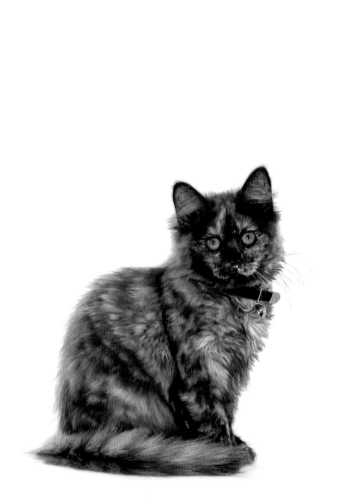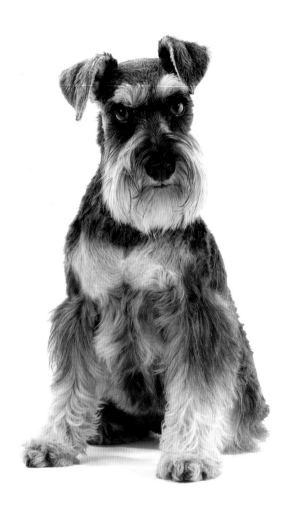

Still, for as many ways as they are different,
cats and dogs share one most remarkable trait ...

They ask only for a smal
but end up claiming the

share of our attention,
whole of our hearts.

Dog person?

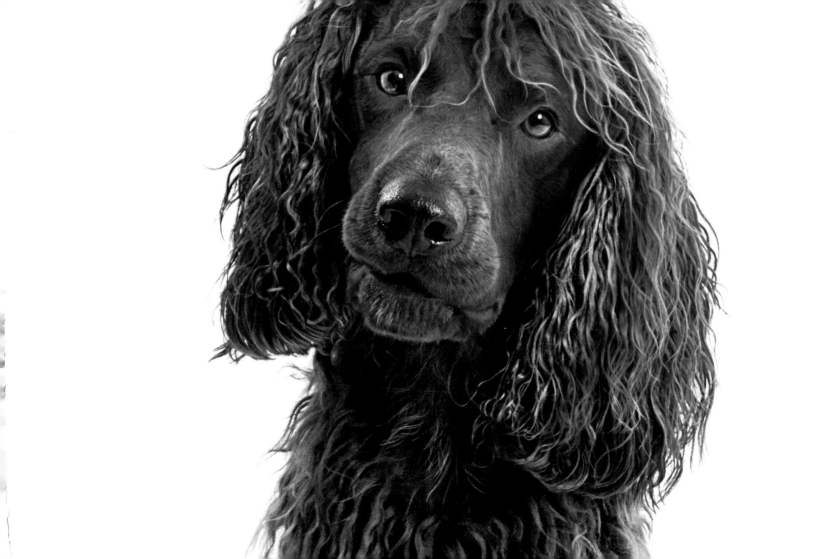

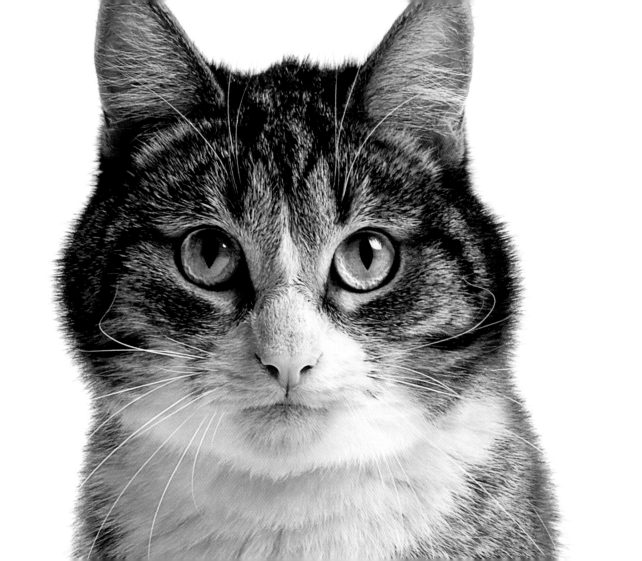

Cat person?

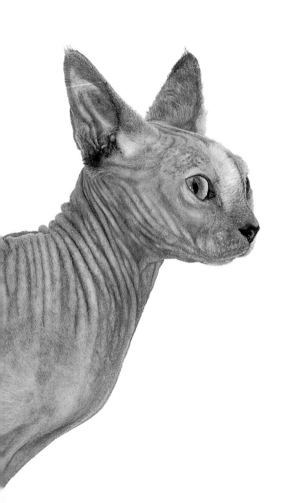

Maybe the
distinction isn't
so important
after all.

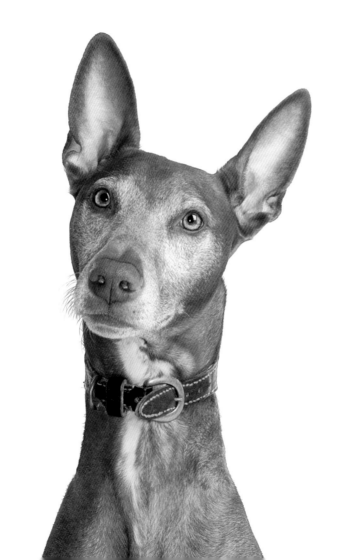

You are truly a *whole* person

when you have loved either ...

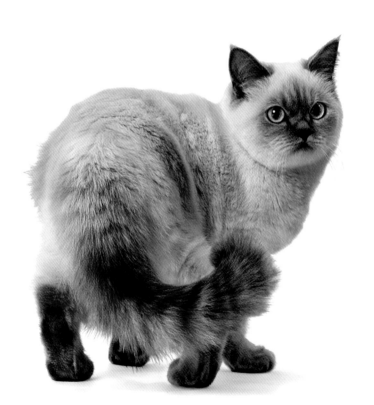

Both ...

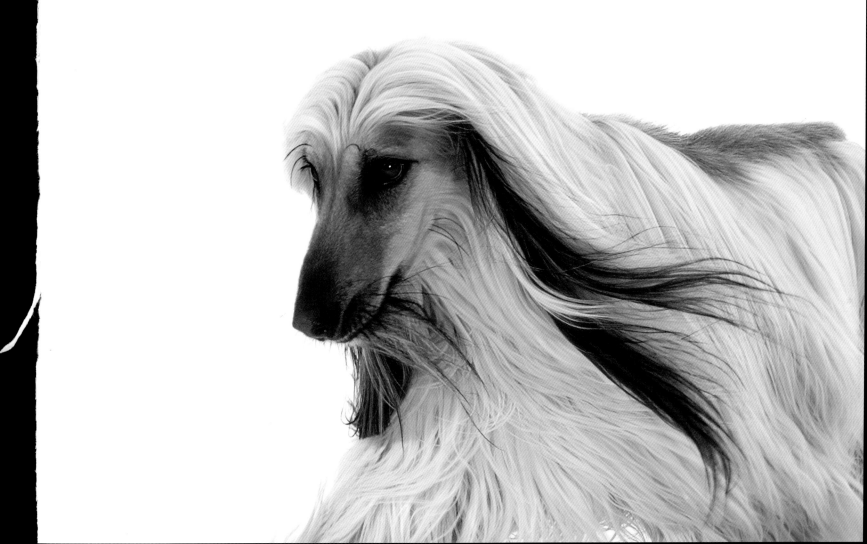

Or all.

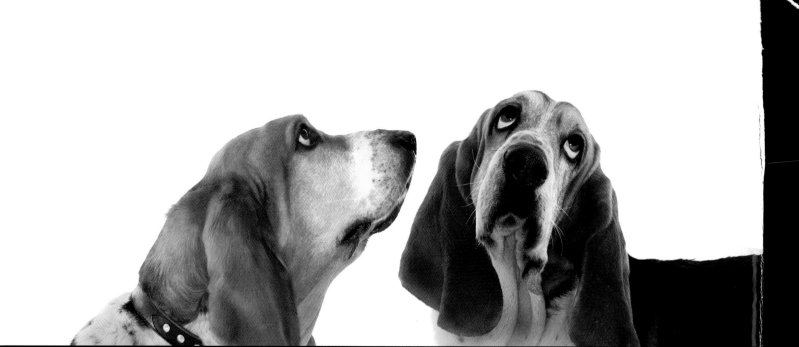